THE ESSENTIAL™

Edward Hopper

BY JUSTIN SPRING

THE WONDERLAND
PRESS

Harry N. Abrams, Inc., Publishers

THE WONDERLAND PRESS

The Essential™ is a trademark
of The Wonderland Press, New York
The Essential™ series has been created by The Wonderland Press

Design by DesignSpeak, NYC

Library of Congress Catalog Card Number: 98-71937
ISBN 0-8362-6998-5 (Andrews McMeel)
ISBN 0-8109-5805-8 (Harry N. Abrams, Inc.)

Distributed by Andrews McMeel Publishing
Kansas City, Missouri 64111-7701

Unless caption notes otherwise, works are oil on canvas

Printed in Hong Kong

Harry N. Abrams, Inc.
100 Fifth Avenue
New York, NY 10011
www.abramsbooks.com

Contents

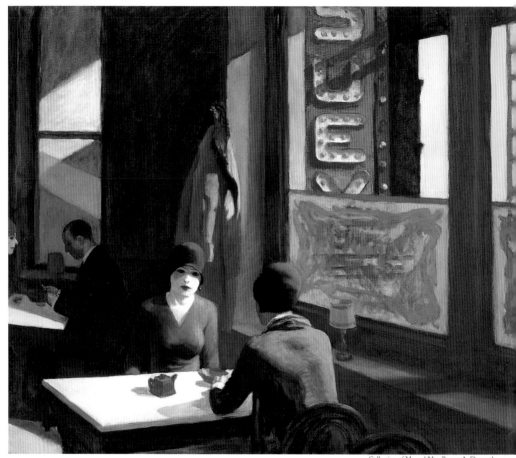

Who *are* these People?

Eerie silence, desolate houses, and blank-eyed individuals with frozen faces, stunned and fixed in time. Cold sunlight from some mysterious, otherworldly source. Unmoving bodies drained of passion and lonely people staring nowhere. Humans occupying the same space but inhabiting different worlds.

What *gives* with Edward Hopper??? Who *are* these alienlike creatures and what kind of static world do they inhabit, with their aimless glances and blocky bodies arrested in time in a kind of "freeze-frame" rigor mortis?

Hopper's paintings are among the most familiar and haunting images in 20th-century American art, yet few people understand their meaning or why the paintings are so powerful. If you're a Hopper fan but aren't sure why, you're not alone. Many people who love Hopper's art, including artists, curators, critics, and even the most astute art historians, are truly confused by it. People know these paintings are important, poetic, and evocative, but they don't know what to say about them.

Welcome to Hopper's world, an unrelentingly quiet and still place, where people seem familiar, yet remain aloof and unengaged, perhaps lost in thought, perhaps just marking time. *What has happened to*

OPPOSITE
Chop Suey
1929. 32 x 38"
(81.3 x 96.5 cm)

these people? Why do they seem so depressed? Why does their world seem to be a place without interest or pleasure? What *is* it with all these inward figures, all these ominous houses, abandoned side streets, and forlorn faces?

The Mysterious World of Edward Hopper

Hopper is the art world's answer to Prozac Nation. Without knowing why, most people have a *visceral* reaction to Hopper's art, feeling lonely and uneasy while looking at his paintings. Detachment is everything in this world: The people he paints languish in a kind of numb, passive reverie, as if in absolute solitude. It is a strangely hypnotic world of awkward silence.

Yet something bonds you to them and arouses within you the feeling that *this stuff is great!* Hopper's art impells you to search for clues in these glassy eyes and pasty faces and lonely hotel rooms and somber brownstones. Most viewers of Hopper's paintings are wary of his bloodless strangers and their lives of missed opportunities and wasted moments. His figures do, however, get under your skin…and there's a good reason for this. His unpeopled paintings and etchings are the stuff of our dreams, and sometimes of our nightmares. Empty, sometimes remote houses with mostly shuttered windows. Vacant rooms where unhappy ghosts are felt to hover. Even sunlight feels menacing in many of Hopper's paintings.

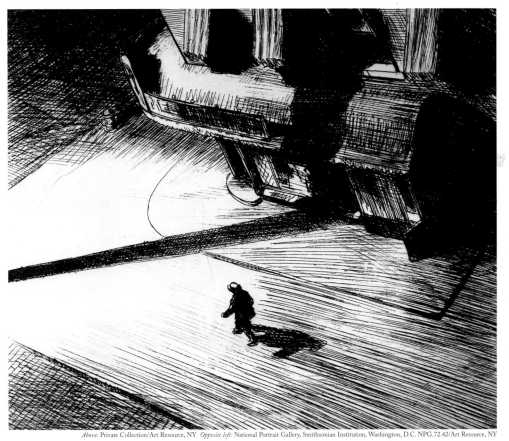

Art First, please!

By looking at the big ideas and images in Hopper's art before jumping into his life—an uneventful one, alas—you'll get a feeling for his odd universe and the techniques he used to create it. Within moments, you'll see why *Nighthawks* is legendary in pop culture and how the house in Hitchcock's film *Psycho* was inspired by Hopper's *House by the Railroad*.

Experiments with Various Art Forms

More than any other American artist of the 20th century, Hopper has captured the look and feel of modern America as it was—and is—experienced by the average American. His artistic output can be neatly divided into four phases:

- **COMMERCIAL ILLUSTRATIONS**

- **ETCHINGS**

- **WATERCOLORS**

- **OIL PAINTINGS**

Hopper's Favorite Obsessions

Regardless of the medium, Hopper returned endlessly—from the early 1900s until his death in 1967—to a core group of **themes** and ideas. *Once you're familiar with these themes and with the way he expressed*

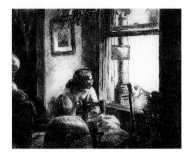

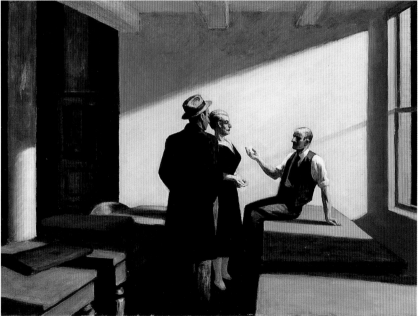

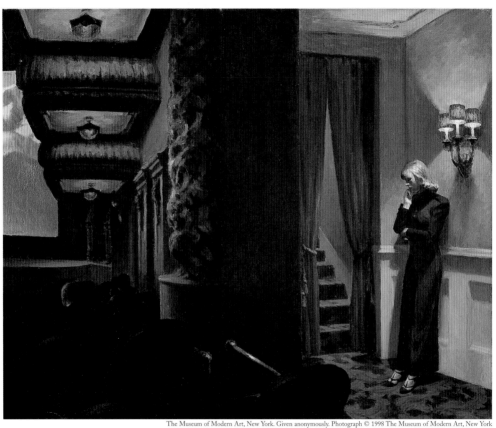

them, you'll know why you're attracted to Hopper. Let's get these themes on the table so you'll begin to understand him immediately:

- **alienation of big-city life** vs. tranquility of the countryside

- **invention of automobiles** and their influence on people's lives: images related to journeys and physical dislocation. In the 1930s, as more people drove, travel increased, and with faster movement, there emerged a growing appetite for exploring new horizons. This destabilized small-town living and tempted people to seek new experiences elsewhere, leading ultimately to an explosion of new values and feelings of displacement and rootlessness

- **rural landscapes blighted by industrial progress** and technology, particularly by **railroads and highways**

- **movies:** a fascination with this new form of escape and entertainment

- **voyeuristic urban scenes,** usually set at dusk or late night

- **an unrelenting lack of communication** among the people in his pictures

- **women in windowed interiors,** suggesting erotic voyeurism

- **lonely, solitary, isolated figures** in spare settings

OPPOSITE
New York Movie
1939
32 ¼ x 40 ⅛"
(81.9 x 101.9 cm)

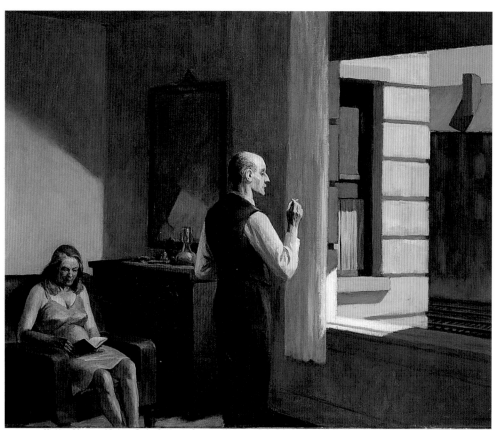

The Hopper Technique

The style of a Hopper painting enables you to identify it immediately as Hopper, even if you're unfamiliar with the image. Much of Hopper is deeply personal and focuses on emotions and situations that were of particular interest to the painter. His underlying themes, however, are universal: the alienation and rootlessness of 20th-century America, as revealed in paintings that depict the life, landscape, and cultural identity of the nation.

OPPOSITE
Hotel by a Railroad
1952
31 x 40"
(78.7 x 101.6 cm)

Hopper achieved this look by narrowly focusing his art in the following ways:

- **no narrative:** Hopper rarely gives details about what's going on in his paintings. This leaves the viewer feeling unfulfilled, but intrigued: The woman in *Western Motel* (see pages 108–109) sits alone, as if waiting for someone. But who? and why?

- **no communication:** Hopper's characters are silent; their lips do not move. In *Room in New York* (see page 29), the characters pursue their private activities, detached from each other; in *Hotel by a Railroad*, the couple is silent, each person engaged in a separate activity.

- **the "viewer viewed":** When we look at Hopper's characters, they often seem to look back at us but rarely make eye contact: The woman facing us in *Chop Suey* appears to be watching the viewer rather than her companion . . . or is she distracted by something else?

ABOVE
Hotel Window
1956
40 x 55"
(101.6 x 139.7 cm)

LEFT
Summertime
1943
29 x 44"
(73.7 x 111.8 cm)

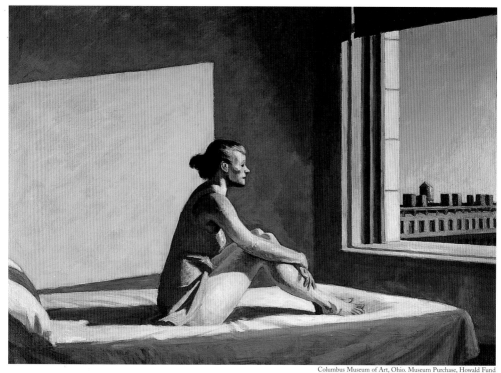

- **voyeurism:** Hopper presents people in the privacy of their bedrooms, hotel rooms, and offices who believe they are alone and who have dropped their guard against the cold world they inhabit. When we glimpse these people in their moments of vulnerability, such as the unsuspecting woman in *Eleven A.M.* (see page 73), it draws out the voyeur in us: Our empathy for these characters arouses in us the same feelings of loneliness and detachment we see in them. We feel uneasy about having invaded their private space.

- **unnatural, cool light:** The light in Hopper's paintings resembles that of a movie set, as if blinding klieg lights sweep his canvases, bathing his characters in an artificial, stagey glow. The woman in *Summertime* stands still, as if waiting for the director's signal; the people in *Sunlight on Brownstones* (see page 85) and *Second Story Sunlight* (see page 107) are profiled by a kind of intense floodlight, as if UFOs are hovering above; the woman in *Morning Sun* sits on her bed, with a rectangular backdrop of sunlight on the wall beside her that seems projected from a nearby screening room. The artificial nature of Hopper's light—often rendered in icy blues—helps create the cold, otherworldly quality of his paintings. No warm, natural sunlight here!

- **the influence of movies:** Hopper uses the cinematic "freeze-frame" technique to capture a split-second moment in his characters' lives. Since the technique focuses on one frame only, the viewer has no idea

OPPOSITE
Morning Sun
1952
28 $\frac{1}{8}$ x 40 $\frac{1}{8}$"
(71.4 x 101.9 cm)

what precedes this moment or follows it: In *People in the Sun*, who *are* these strange people sunbathing in their business attire? And what brought them together here? (And where, exactly, is "here?")

OPPOSITE
People in the Sun
1960. 40 x 60"
(101.6 x 152.4 cm)

- **timelessness:** We share the emotions of Hopper's characters—fear, uncertainty, loneliness, and alienation—because they are as real today as they were when Hopper created his paintings.

- **rejection of modernism:** Hopper distinguished himself from his contemporaries by spurning avant-garde experiments in modernism, focusing instead on realism and creating scenes with people in them. He painted offices, gas stations, abandoned houses and street corners, motel rooms, ordinary situations with ordinary people. Viewers can easily identify with Hopper's people and locales.

Hopper's Realism

Hopper is known as the greatest 20th-century American realist because:

- his paintings present highly specific representations of everyday life—candid "snapshots" rather than moralistic or allegorical images

- his work portrays human figures, architecture, landscape, and light in a dramatic, instantly recognizable manner

While it is true that his later work is vaguely surrealistic, his hallmark paintings and style of earlier years are clearly within the arena of realism.

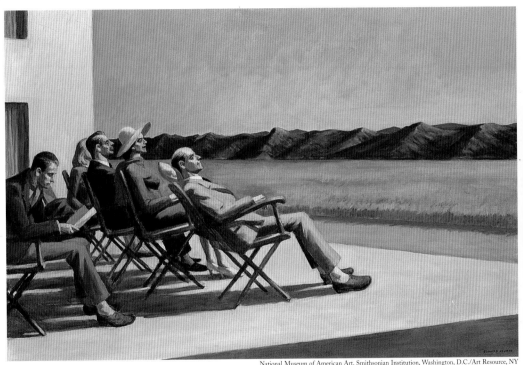

The Two-Way Mirror

We look at a Hopper painting and, before we know it, we're wondering about the characters he has painted, trying to figure out what's going on in their minds and in their lives.

And yet, they have no stories to tell; they exist merely as images in a painting. Some people who look at Hopper's paintings have responded to these characters like characters in fiction, with empathetic feelings of loneliness and alienation. To these people, Hopper's paintings seem to be revelations: pictures that serve as a mirror for their own thoughts and feelings.

So where does this come from, this dark, disturbing, anxiety-ridden world of loneliness and alienation?

Edward Hopper—American as Apple Pie?

At heart a loner, **Edward Hopper** (1882–1967) is the most famous American realist of the 20th century. Along with **Norman Rockwell** (1894–1978), he created some of the most familiar images in American realist art. But unlike Rockwell, who painted warm, nostalgic scenes of a home-and-hearth America, Hopper fashioned a disturbing vision of a country jarred by change and uncertainty.

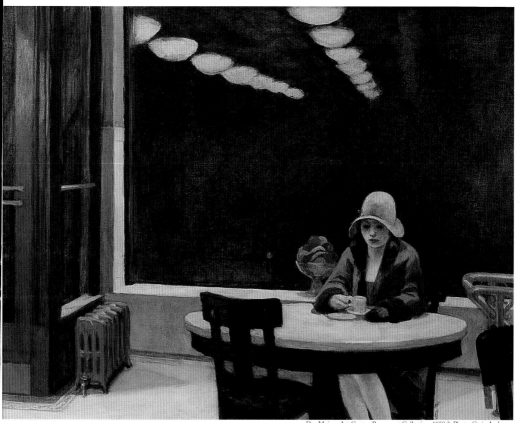

Born in an industrial era, where speed and progress were in vogue, Hopper witnessed the old being left behind for the new in an endless shift from rural to urban America. People moved from friendly, slow-paced towns to the stifling environments of big cities, with their frantic energy and impersonal momentum. The two big inventions of Hopper's time—**automobiles and movies**—were such major influences on his art and life that even a passing awareness of them helps unlock the meaning of his paintings.

One of the reasons Hopper lingers in the imagination is that **his paintings make people uncomfortable.** Even his "pretty" paintings, such as *Railroad Sunset,* can seem oddly creepy. Hopper's genius lies in his ability to communicate his troubled inner life effectively through his paintings, in a vision that at first seems outward-looking and "realistic," but that shifts to one tinged with a profound sense of cosmic loneliness and anxiety.

The Artist's Personality: Is it a "Key"?

Most people who look at Hopper's paintings wonder what he was like. The truth is, he was **a shy and guarded man** who disliked and avoided artistic debate. He declined to answer questions about his paintings or his private life, particularly when journalists, intrigued by his later paintings, speculated on Hopper's personality and sexual imagery. Hopper suffered, as do many artists, from depression, loneliness, and

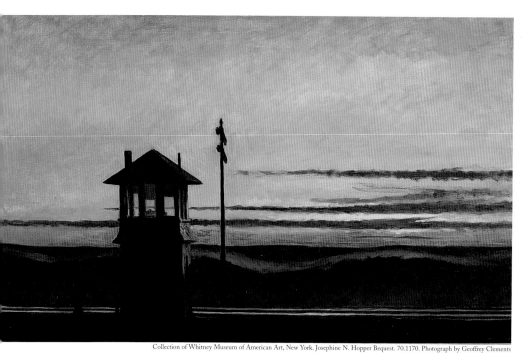

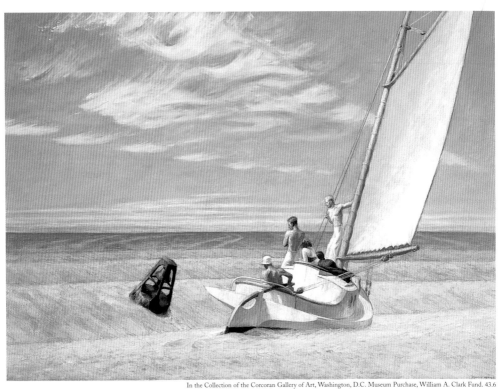

anxiety about his ability to create. Later in life, these emotional problems were compounded by a thyroid condition that affected his moods and energy level. A bachelor into his early forties, Hopper married an artist with whom he would have an occasionally quarrelsome but essentially companionable lifelong relationship. He kept no personal diary *(but she did!)*, wrote few letters, and had few friends.

So who *was* Hopper???

Edward Hopper was **born on July 22, 1882,** in Nyack, New York, a peaceful, affluent little town on the west bank of the Hudson River twenty-five miles north of New York City. The community was (and still is) well known for its large, elegant homes built in late Victorian styles. Hopper grew up in a modest clapboard home at 53 North Broadway, the town's main street. His parents, **Garrett Henry Hopper** (1853–1913) and **Elizabeth Griffiths Smith Hopper** (1854–1935), descended from Dutch-English ancestors who had lived

FYI: Nyack was known for its boats and breathtaking views of the wide, slow-moving river. From his earliest years, Hopper had an interest in nautical life; as a young man, he built and sailed his own small boat, an activity that may have appealed to him because it allowed him to spend time alone. Hopper's early interest in maritime subjects would reassert itself later in his art, as would the related themes of travel and escape.

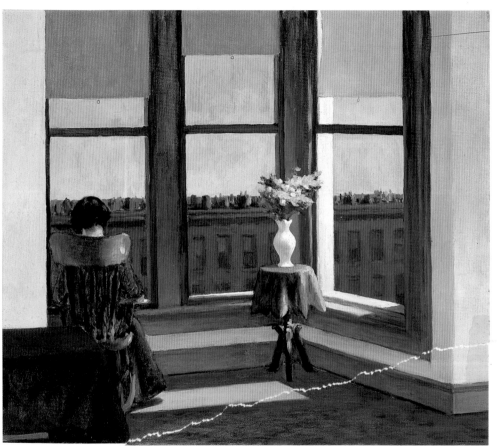

in America for generations. His mother had artistic inclinations; his father, an unsuccessful businessman, enjoyed literature. The couple had been married for four years when Hopper was born; his only sibling, a sister named Marion, was two years older than Hopper.

A Shy Childhood among Snooping Neighbors

The Hoppers had **close ties to the community.** Hopper's maternal great-grandfather had founded a Baptist church in Nyack, so his mother's family were well known in the town as church folk, and Hopper grew up in a **strict Baptist environment.** His father was in the dry goods business and in 1890 purchased a store on the town's Main Street. But his lack of success created a longterm concern within the family about financial security. As a young boy, Hopper helped out by working in the dry goods store. His shyness may have developed, in part, out of the constant, unavoidable presence of neighbors and acquaintances.

Can't Keep the Kid from Pencil and Paper

As a child, Hopper drew pictures constantly and enjoyed spending time alone indoors, reading and drawing. But his parents, like most parents, worried about him and pushed him to spend time outdoors with other children. As he grew, Hopper preferred to observe the world from a distance and to record his impressions in his drawings and sketches rather than to engage in chitchat.

OPPOSITE
Room in Brooklyn
1932. 29 x 34"
(73.6 x 86.3 cm)

BACKTRACK:
WILLIAM MERRITT CHASE

Chase has been called both an American Impressionist and an Impressionist-influenced realist. He enjoyed great commercial success during his lifetime, and counted Georgia O'Keeffe (1887–1986) among his students.

BACKTRACK:
THOMAS EAKINS

Thomas Eakins of Philadelphia, a creator of American realism, studied art in Paris during the 1860s, then returned home in 1870 to employ his expertise in the technical aspects of painting—including perspective and anatomy—in works that eventually made him famous. His realistic, carefully studied pictures depict industrial American society, figured landscapes (i.e., with people in them) and interiors.

After first attending a private school, Hopper transferred to Nyack Public High School, where he was sometimes teased with the nickname "Grasshopper" (at the age of 12 he had grown to the freakish height of six feet). The trauma of sudden growth furthered his social ostracism; as a result, the naturally shy Hopper became *even more uncomfortable and withdrawn.*

As soon as Hopper could leave Nyack, he did so, heading for the bright lights of Manhattan.

New York: Bright Lights, Big City

By the time he graduated from high school in 1899, Hopper had decided upon a career a painter. But his parents, being practical folks, wanted him to get a job and support himself. So during his first winter in New York City, he **studied commercial illustration** at the Correspondence School of Illustrating.

He soon decided, however, that the best place to study art was at the New York School of Art on West 57th Street, also known as "the Chase School" after its most famous teacher, the highly popular painter **William Merritt Chase** (1849–1916).

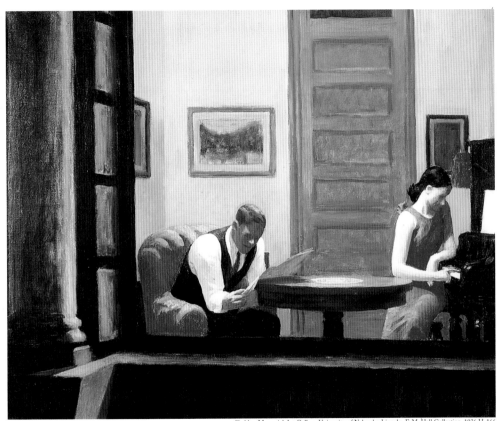

PREVIOUS PAGE
Room in New York
1932. 29 x 36"
(73.7 x 91.4 cm)

OPPOSITE
The Sheridan Theatre. 1937
17 ⅛ x 25 ¼"
(43.5 x 64.1 cm)

Hopper began his studies at the New York School of Art by studying oil painting with Chase, but from the start he disliked Chase's elegant, fussy style. Chase's pictures of beautiful scenery and women in sun bonnets seemed outdated to Hopper, who instead began taking classes with the brash and influential **Robert Henri** (1865–1929) and the genial, perceptive **Kenneth Hayes Miller** (1876–1952).

During his six years at the New York School of Art (1900–1906), Hopper studied the work of the top American artists, including the noted American realist, **Thomas Eakins** (1844–1916). He also learned about the 19th-century landscape movement known as **Luminism.** During his career there, Hopper won many prizes and scholarships for his ability as an artist and draftsman.

Hopper considered Thomas Eakins America's greatest painter, for he felt Eakins had observed the American scene without sentiment or pretense. Though Eakins eventually made a name for himself as a portraitist, he initially shocked his clients by showing them in natural

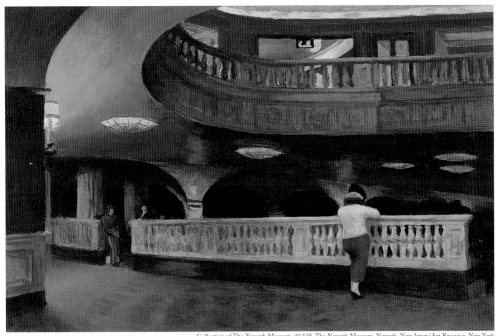

> **FYI:** Eakins's paintings, despite their realism, have a quality of light that is far from being "natural." Whether indoors or outdoors, his is a cold, physically unflattering light. This often **dehumanizing use of light** fascinated Hopper, who would eventually favor images lit with similarly harsh and unsettling light, as in *Automat* (page 21) or *Nighthawks* (pages 96–97).

rather than idealized form—flush-faced, slumped over, warts and all. The great **scandal of Eakins's career** came when the Philadelphia Academy dismissed him in 1886 for having **male models pose nude** before his women students—a shocking affront to genteel Philadelphia society. But with his dismssal from the Academy, Eakins had made his point: He had dedicated his career to advancing an uncompromised pictorial realism.

An Important Early Mentor: Robert Henri

Perhaps the most influential teacher of Hopper's day was the dashing and iconoclastic Robert Henri. *(The name looks French, but he was American and pronounced his name "Hen* **rye***")*. Henri felt that art should communicate character and emotions, and he was particularly interested in **portraying the life of the working class.** He hoped that by depicting the poor in his art he could further the cause of the workers, for he felt that art should do more than simply furnish the homes of the rich. Henri inspired an entire generation of artists to look for a way to make art a part of everyday life for ordinary people. He

was influential in promoting the idea, widely held during the first half of the century, that **art could change people's social consciousness.**

No Paris Yet—Back to Henri's Class

Hopper was not alone in his enthusiasm for the teaching style of Robert Henri. The Henri class at the New York School of Art included a number of others who went on to fame and success, even though their work is less well known today than it was during their lifetimes. Henri's students included Hopper's good friend **Guy Pène du Bois** (1884–1958) and **Rockwell Kent** (1882–1971).

Hopper Learns from "The Eight"

Robert Henri is best remembered today as the founder of the art movement known as **The Group of the Eight** or **The Eight.** The group, whose members included the talented artist **John Sloan** (1871–1951), protested against the narrow academic standards that were being applied to American painting. They believed *art should*

> *FYI:* **American Luminism**—This was a 19th-century form of American landscape painting (from the Latin "lumen," for light), best known for a far-flung group of artists who were interested in a naturalistic, essentially unromantic form of landscape characterized by a passion for depicting space, light, atmosphere, and time of day.

reflect everyday American life and be accessible to all. The Eight were opposed to the earlier idea of "art for art's sake" (where art was usually purchased by the wealthy) and to the pretty, Frenchified vision of America presented in the paintings of William Merritt Chase.

The Eight and their followers evolved in different directions as the century progressed. Some of them, such as **Thomas Hart Benton** (1889–1975), shared Hopper's passion for travel and held strongly nationalist sentiments: Their movement became known as **Regionalism** or American Scene painting. Others, concentrating on nitty-gritty scenes of urban life, became known as the **Ashcan School.** Still other artists chose to illustrate the political and sociological struggles of the working class during the politically turbulent 1930s. The latter group, many of whom created socialist- or communist-themed murals, became known as Social Realists.

Early on, Hopper admired the Ashcan School, calling it "the first really vital movement in the development of a national art that this country has yet known." Hopper himself is often counted by art historians as

> **FYI:** You'll see the term written as both *Ashcan* and *Ash Can*. Some critics avoid the term by describing this school as a later incarnation of The Eight. An ash can, by the way, is an old-fashioned barrel-like container for holding ashes left by coal fires. The Ashcan name was intended to suggest the harshly realistic subject matter of its paintings.

an Ashcan painter, because he frequently painted unromanticized scenes of urban life. But later in his career, **Hopper rejected the "Ashcan" label as narrow and limiting.**

Pack up the Paint Box: Crucial Trip to Paris and Europe

During the early part of this century, no young artist's education was complete without a trip to Europe to observe, record, and absorb the latest developments in art. In 1906, Paris was the center of the European art world.

Hopper had always wanted to go to Paris. From an early age, he had read French literature in translation and had learned from Robert Henri to value French painting and poetry. When he went abroad in October 1906, he visited museums in England, Holland, Germany, and Belgium, but it was in Paris, the city of light, where Hopper settled to paint. It was here that his future style and technique would begin to take shape.

Hopper's adventures in Paris were not as romantic as the ones he had read about. Through his parents' church connections, he took a room in a Baptist mission, where his comings and goings were scrupulously observed and reported upon by a number of maternal older women— one of whom described him approvingly, in a letter to Hopper's mother, as a **"Mama's Boy."** Nonetheless, Hopper was well situated at the mission, for the building at 48 rue de Lille, in the seventh arrondissement, was close to the Seine and all the large museums.

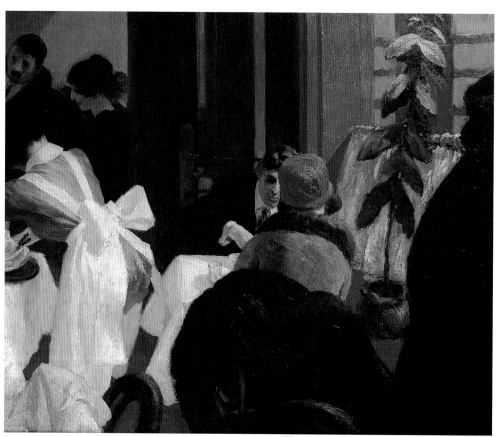

Never one for an active social life, Hopper avoided the bohemian gathering spots in Paris, in part because he was shy, but also because he lacked appropriate introductions. Instead, he went to museums, galleries, and exhibitions. He roamed through the city, visiting cafés and bars, and became intrigued by Parisian street life. In a letter to his parents, he observed that "the workmen here seem to be in a perpetual state of protest." A military buff, he drew French soldiers in their colorful uniforms. Though he made no mention of it to his parents, **Hopper began watching the Parisian prostitutes** and their pimps, frequently sketching them in caricature as he sat at sidewalk cafés. (This lifelong habit of eyeing "loose" women would become a signature element of his painting.) Along with his sketching, Hopper—a realist in the making—bought a camera to record his many impressions.

Hopper sees Impressionism

Hopper saw a lot of Impressionist paintings while in Paris. But the autumn of 1906 was cold and rainy, so he had little opportunity to paint outdoors in the Impressionist style. Still, exposure to French art had led him to lighten his palette and to imitate the Impressionist (broken) brushstroke, at least for a while. The Impressionist painter whose work had the deepest effect upon Hopper was **Edgar Degas** (1834–1917), whose work introduced Hopper to the idea of picture compositions that were casually off-center and seemingly haphazard— an idea that Degas had borrowed from photography.

Impressionism is a style
of painting developed
by French painters of
the 1870s who sought
to depict fleeting visual
impressions, often paint-
ed directly from nature,
by means of dabs or
strokes of color that
simulate actual reflected
light. The term
Impressionism derives
from a title of a painting
by **Claude Monet**
(1840–1926) entitled
Impression—Sunrise
(1874). Other important
Impressionists include
Pierre-Auguste Renoir
(1841–1919), **Edgar
Degas** (1834–1917),
and **Camille Pissarro**
(1830–1903).

Hopper questions the Social Role of Art

Even in giddy Paris, Hopper continued to ponder the role of art in society. In this context, ***Impressionism seemed silly to him,*** for while some Impressionists painted ordinary people within the urban environment, their imagery usually stopped short of social commentary. Impressionist depictions of cafés, picnics, and street scenes were usually lively studies of pleasure and light, with occasional excursions into the darker aspects of that world. Impressionist landscape painters had similarly ignored the grim, heavily industrialized urban world in favor of sunlit gardens and idyllic countrysides.

While charmed by the pretty cafés and elegant boulevards, Hopper noticed that the French did not share his lonely, somewhat dark view of the world. After initially feeling at home among the art-loving French, he began to feel like an outsider again.

Anxious to know about which subject matter and painting style he might like to pursue, Hopper visited the **1906 Salon d'Automne,** the official yearly exhibition of the Paris art world. That year the exhibition featured a 30-work retrospective of the Realist painter **Gustave**

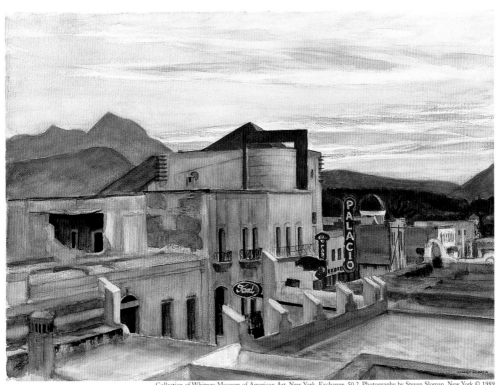

Courbet (1819-1877) and a large showing of work by the post-Impressionist **Paul Cézanne** (1839–1906). Cézanne's experiments with the simplification of form would be of seminal importance to the development of 20th-century art, and this exhibition would be a landmark in modernist art history. But Hopper's only comment on the Cézanne paintings he saw was that they seemed "very thin."

At the 1906 Salon, it was Courbet, not Cézanne, who impressed Hopper most deeply. In Courbet, Hopper had found a grim and thoughtful soulmate, an artist equally committed both to socially significant art and to the art movement known as Realism.

> **FYI: Courbet and Realism**—In a general sense, the term *Realism* refers to objective representation. Among art historians, it refers specifically to a 19th-century French movement that rejected idealized and elitist academic styles in favor of everyday subjects depicted in a blunt and straightforward manner. Led by the political painter **Gustave Courbet** (1819–1877) and the novelists **Gustave Flaubert** (1821–1880) and **Emile Zola** (1840–1902), this movement had close ties to the democratizing French political movements of the time. Courbet courted scandal by portraying everyday scenes from contemporary life on a large scale, which, up to that point, had been reserved for the painting of more "noble" subjects. Courbet's works shocked the public with the supposed ugliness of his controversial genre of "everyday" paintings.

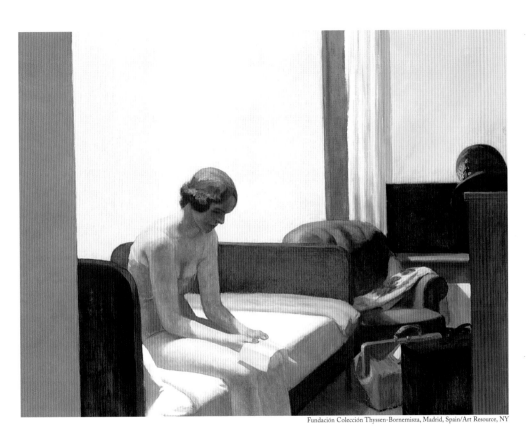

The artistic and literary movement known as *modernism* broke with past traditions and rejected the nitty-gritty representation of realism in favor of a succession of avant-garde, abstract styles. Modernism cannot be defined as a single "school" with specific dates, but refers more to reactions against the status quo and a rejection of traditional forms of art. The great early champion of modernism in New York was the photographer Alfred Stieglitz (1864–1946), whose 291 gallery was a hotbed of American modernism beginning in 1905.

In his drawings of the urban landscape of Paris, and even in his street and café scenes, Hopper began to describe the anonymous nature of the sprawling urban environment and its dislocating effects on people. In his rare and important early works of Parisian life, he began his lifelong project of portraying humans detached from nature, society, and themselves.

Hopper to Modernism: *No Thanks*

As early as his Paris years, Hopper showed disdain for modernism, though by the time of the 1913 Armory Show in New York, modernist thought had firmly established itself in America as well as in Europe. Soon enough, Hopper and his fellow realists would be eating the dust of the fast-moving modernist avant-garde, whose more cerebral forms of art captured the attention of viewers, dealers, collectors, critics and, ultimately, art historians. But Hopper remained anti-modernist throughout his life. He found it too cerebral and preferred to focus on an "objective" depiction of real life and nature.

While the rest of Paris debated issues of modernism, Hopper haunted the embankments, parks, and cafés, creating melancholy realist images of urban life, such as

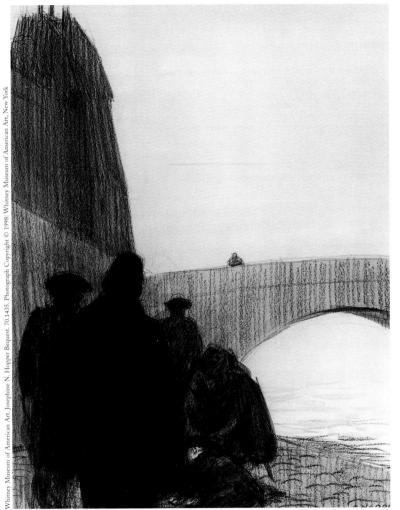

*On the Quai:
The Suicide*
1906-09. Conté
crayon, ink wash
and graphite
on paper; sheet:
17 $^{7}/_{16}$ x 14 $^{11}/_{16}$"
(44.3 x 37.3 cm)
image: 13 $^{3}/_{8}$ x 10 $^{3}/_{8}$"
(34 x 26.4 cm)

his drawing, *On the Quay: The Suicide* (1906–1909), which depicts the body of a suicide victim who has just been pulled from the river.

NYC...Paris...NYC...Paris...NYC...Paris...NYC

In August 1907, Hopper returned to America but revisited Paris in the summer of 1909, staying about six months. The following summer, he made his third and final trip to Europe, this time for about four months, visiting both France and Spain.

From the time of his return to New York in 1910, Hopper had to scramble to make a living. For some time, he was unable to paint because he was busy paying the rent by working as a commercial illustrator. It was not a happy time, since he dreaded illustration work, but he managed to earn a living and painted whenever he could, particularly during his summer holidays in New England.

Hopper never mastered the art of drawing beautiful and fashionable women, and as a result he never made a lot of money with his illustration work. Eventually, however, he established a name for himself as a talented illustrator of industrial and railroad scenes. He learned from his experiences as an illustrator that art had its business side: From 1913 to his death in 1967, Hopper recorded every single sales transaction, either for his commercial illustrations or for his art, in one large ledger book.

Hopper's Illustrations: Not Half-Bad

Despite his anti-commercial paintings of small-town America and big-city entrepreneurs, Hopper excelled as an illustrator for large corporations and drew a comfortable salary from them. His commercial illustrations of the period are of interest, since they show French influences, particularly of Degas, and an awareness of the expatriate American painter **James Abbott McNeill Whistler** (1834–1903). Moreover, Hopper's work as an illustrator gave him a distinctive view of the world that resurfaced later in some of his best paintings, such as *Office at Night* (see page 94), where he depicted voyeuristic scenes of commercial interiors and office life.

As Hopper re-established himself in New York, he abandoned the lighter, Impressionist-inspired palette he had adopted in Paris for a darker, more substantial one, in part because **darker colors were more true to Hopper's temperament,** and in part because of the influence of fellow painter John Sloan.

A Key Influence: John Sloan

During these difficult early years (1910–15), Hopper began to look at the work of John Sloan, with whom he had studied briefly in his last semester at the New York School of Art in 1906. **He was impressed by Sloan's concern for the human condition** and his pictures of

urban and domestic life among the working classes. Through Sloan, Hopper began to see the potential of scenes depicting everyday life.

Sloan and Hopper were very different, both as artists and people. Sloan was active in a movement for social reform, working as an illustrator for *The Masses,* a rabble-rousing socialist publication. Hopper, on the other hand, was resigned to live within the structures of capitalism: Though he disliked his stressful, low-paying life as a freelance illustrator, he was essentially apolitical and did not yearn for revolutionary change.

An Important Year: 1913

In 1913, two landmark events occurred in Edward Hopper's life: He moved into a modest Greenwich Village apartment at 3 Washington Square North, a brownstone studio he would inhabit *for the rest of his life.* And his work was included in the **1913 Armory Show**.

Sound Byte:
"One of the weaknesses of much abstract painting is the attempt to substitute the inventions of the intellect for a pristine imaginative conception. Painting will have to deal more fully with life and nature's phemomena before it can again become great."

—HOPPER, in 1953

The 1913 Armory Show had been organized by a protest group, the American Association of Painters and Sculptors, as an alternative to a more restrictive exhibition held by New York's National Academy of Design. The organizers originally planned to show only American artists, but after a trip to Europe, decided to include the most radical new European art. The controversial exhibition traveled from New York to Chicago and Boston, and in the end attracted more than 300,000 people. *The show was a mega-blockbuster.*

The Armory Show gave Americans their first glimpse of various wild-and-crazy European art movements, including Cubism, Expressionism, Fauvism, Neo-Impressionism, Symbolism, Neo-classicism, and "primitivizing Realism." The most scandalous painting exhibited was the Cubist *Nude Descending a Staircase* (1912) by the French artist **Marcel Duchamp** (1887–1968), which was described by one baffled critic as "an explosion in a slat factory." More traditional forms of European art were also on display at this exhibition, including works by **Jean-Auguste-Dominique Ingres** (1780–1867), **Eugène Delacroix** (1798–1863), **Camille Corot** (1796–1875), Gustave Courbet, and the Impressionists.

Hopper...at the Armory?

Because Hopper rarely made public comments, one can only imagine his response to the acres of modernist works surrounding him at the

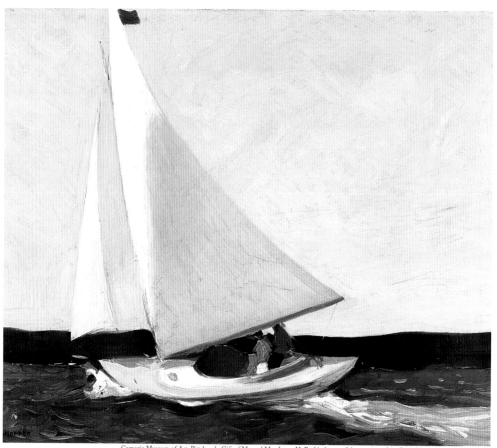

Carnegie Museum of Art, Pittsburgh. Gift of Mr. and Mrs. James H. Beal in honor of the opening of the Sarah Mellon Scaife Gallery. 72.43

Armory Show. What he did record was the sale of his first painting, *Sailing*, for $250. Hopper may have felt that his career had finally taken off as a result of this sale, but in fact ten years would pass before he would sell another piece and find both critical and financial success.

OPPOSITE
Sailing. c. 1911
24 x 29"
(60.96 x 73.66 cm)

Hopper's Apartment: Exactly What you'd Expect

Hopper's simple studio apartment was located 74 steps up from the street. It was heated only by a coal stove, for which Hopper hauled his own coal using a dumbwaiter. The closet-sized kitchenette was equipped with only the most primitive appliances. Since there was no bathroom, Hopper shared a toilet down the hall with other residents of the building. Nineteen years later, in 1932, he would move to a slightly larger apartment on the same floor, this one facing south over Washington Square. But he would remain on the same floor of the

same brownstone, sharing the same communal toilet, from 1913 until his death. His decision not to change his lifestyle over the years was indicative of his spartan eccentricity.

On the door of his new apartment, Hopper jokingly placed a small sign in French reading **"Maison E. Hopper, 3 Washington Square,"** advertising his services as an artist and teacher. Even though he had been back in New York for three years, Hopper still felt an attachment to the artistic life of Paris. It was with Paris in mind that he began the only major painting of his early New York period, *Soir Bleu*.

The Total Failure of *Soir Bleu*

Hopper's *Soir Bleu* (1914), one of his largest canvases at 3 x 6', depicts a café scene on the old rampart of Paris, an area popular among the Parisian demimonde. The title means "Blue Night" but refers to the twilight hour, which had been celebrated by French poets as the time of day colored by romance, melancholy, and erotic possibility. Set in a café, the painting includes a pimp, possibly a prostitute, and a glum-looking clown smoking a cigarette. The image describes the dangerous, sexy, melancholy world of Paris at night during a traditional street carnival—a detail that is significant only because it explains the clown suit.

This striking image borrows its distinctive color, dark mood, and ghastly evocation of artificial light both from the Expressionist café

scenes of **Henri de Toulouse-Lautrec** (1864–1901) and from similar scenes by Degas. But it also suggests the grim sexual scenes of American life that Hopper would eventually pursue. So it's an important transitional work. Compare *Soir Bleu*, for example, to *Automat* (page 21), with its provocative young woman seated alone, or to *Nighthawks* (pages 96–97), with its atmospheric night "café," and the relationship becomes clear: Like *Soir Bleu*, these are French-inspired "café" paintings, but they have been transformed into somber American settings in which a late-night diner replaces a glittering Parisian café.

Hopper had high hopes for *Soir Bleu*, but critics disliked his heavy-handed, caricature-like depiction of Parisian lowlife. The subject matter baffled them: What did this painting of a French café have to do with New York? Though French art had featured prostitutes and *demimondaines* for years—Manet's *Olympia* (1863), for example, had been scandalous in Paris when first shown—Americans were shocked by the depiction of a prostitute in a New York exhibition. The bottom line was that this entirely Parisian image made no sense to New York

> **FYI:** The less-than-subtle "clown" imagery in this first major oil painting of Hopper's career will reappear in the last painting of his life, *The Comedians* (1965). In the latter (seen on page 110), Hopper—by then deeply conscious of his own mortality—depicts his wife and himself in similar "clown" costumes, taking their final bows together at the edge of a stage.

E. HOPPER

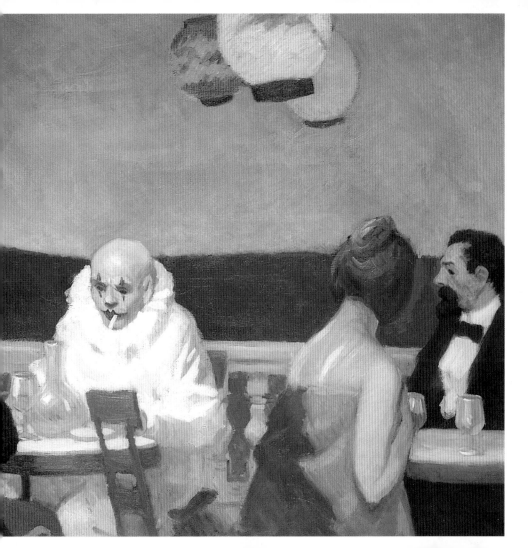

audiences, who saw it as pretentious, pornographic, and, to top it all off, a bit silly. The work was received so unkindly that from the time of that exhibition until his death, Hopper kept the painting rolled up in the back of his studio and forgot about it. Today, however, critics recognize it as a turning point in his career.

This 1915 painting would be the last of Hopper's Paris-inspired images. With *Soir Bleu*, Hopper had learned his lesson—namely, that the most suitable subject for an American realist painter was…America.

A Turning point: the Etchings

After the critical failure of *Soir Bleu*, **Hopper became less active as a painter.** During the years 1915–23, he found increasing success as a freelance illustrator. In October 1918, a World War I poster competition brought him the success that had eluded him with *Soir Bleu*. His entry was a four-color war poster entitled *Smash the Hun*, a simple graphic image of a patriotic factory worker wielding a sledge hammer. The $300 prize was the first prize Hopper had won since his days at the New York School of Art. With the cash award came increased recognition as an illustrator, and (more important) increased pay for his work.

Through his work in the graphic arts, Hopper realized that the simplest images were often the most powerful. This elemental discovery would soon be reinforced through his work in etching and printmaking.

His good friend, Guy Pène du Bois, organized Hopper's **first one-man show** at the Whitney Studio Club in New York City, in January 1920. Hopper, 37 and unmarried, had up to this point been a **failure** as a painter, and unfortunately the show did nothing to change that. More than half the works he exhibited were his French paintings from a decade earlier. A second show, of watercolor caricatures he had done in Paris, followed two years later in 1922. Sadly, Hopper was unable to come up with suitable work for either of these exhibitions, as he had painted nothing significant since his days abroad. He had been too busy earning a living.

Nonetheless, **a change was coming.** In his free time, Hopper had begun creating images in a medium new to him: etching. The change of medium reinvigorated him. With his printing work, Hopper finally turned his eye away from France toward America.

Hopper began making etchings in 1915. He exhibited his prints from 1920 onward and won two prizes for them in 1923. *American Landscape* (1920) bears a strong compositional and thematic similarity to the painting that, five years later, would establish Hopper's reputation: *House by the Railroad* (see page 70). Here, Hopper depicts a farm family's life disrupted by industrial progress (the railroad). The cows clamber awkwardly over the tracks, through the twilight, toward the farmhouse and barn. The image stops just sort of sentimentality, saved by its own somber simplicity.

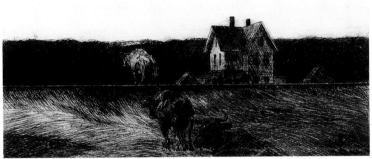

Night Shadows (1921), an intriguing and mysterious etching of a city street at night, is another good example of Hopper's development during this period (see page 7). The scene, viewed from above in a disorienting and somewhat dizzying fashion, is lit by a streetlight that throws shadow and light in unexpected directions. Note Hopper's sophisticated awareness of architectural detail at top right, and the contrast of bright white paper with deep, velvety-black printing ink throughout the work. Hollywood cinematographers were inspired by this etching while creating the shadowed, black-and-white film genre of the 1940s known as *film noir.*

OPPOSITE
Evening Wind
1921. Etching
7 x 8 ³⁄₈"
(17.8 x 21.3 cm)

LEFT
American Landscape
1920
Etching; sheet:
13 ¹³⁄₁₆ x 18 ¼"
(35.1 x 46.4 cm)
plate: 7 ³⁄₄ x 12 ¹⁵⁄₁₆"
(19.7 x 32.9 cm)

Lessons Hopper Learned from Etching

Hopper found that his illustrating experience and ability to envision imaginary spaces and tableaux enabled him to "invent" interiors and landscapes that had maximum psychological effect. His work in this black-and-white medium forced him to pay close attention to the three essentials of image-making: **subject, composition, and light.** During this period, Hopper effectively zeroed in on the kind of imagery he wanted to create. The results were simple, stark, and beautifully

> *FYI:* **Etching—or "Hopper on Copper"**—Etching is a graphic art form in which images are created on metal plates, which are then inked and "pulled" in a printing press, where the ink transfers the "drawing" onto paper. The artist first coats the metal plate with a protective covering, or "ground," and then scratches away that ground using a sharpened needle, thereby creating the drawing. The plate is then immersed in an acid bath and the lines drawn on the plate are corroded by the acid. The exposed metal dissolves away and these "bitten" lines are used to hold the ink that is rubbed onto the plate. The ink is forced into paper when the inked plate and dampened paper are run through the printing press. Etchings are usually made on copper or zinc. (Hopper used copper.) The biggest challenge that etching poses to the artist is that of composition: In the process of being transferred to paper, the drawing on the metal plate is reversed, which demands that the artist must create the drawing backward on the plate in order to achieve the desired result on paper.

crafted. Critics responded positively to the best of these etchings, one noting that Hopper had "a genius for finding beauty in ugliness."

As Hopper worked in etching, he:

- settled upon new, open-ended, and evocative (rather than allegorical or moralistic) imagery

- focused on the expressive qualities of American architecture, referring to "our native architecture with its hideous beauty, its fantastic roofs, pseudo-Gothic, French, Mansard, Colonial, mongrel and whatnot"

- paid close attention to extremes of light and shadow, particularly to artificial light and nightscapes

What's more, Hopper developed several strong compositional tactics that would profoundly influence his later paintings:

- a simple frontal view parallel to the picture plane

- scenes viewed from above, at an angle

- subjects placed on a slanted axis

Finally, Success in...(surprise!) Watercolor

Though Hopper made significant progress in printmaking, his first real success came in an unexpected medium—watercolor. During the summer of 1923, an acquaintance, **Josephine ("Jo") Verstille Nivison** (1883–1968), whom Hopper had known since his art school days, encouraged him to take up watercolors while the two were summering in Gloucester, Massachusetts. Watercolor was a medium Hopper had rarely worked in since his days as an art student, yet the medium suited both his talents and inclinations. To his own surprise, the results were superb.

OPPOSITE
The Mansard Roof
1923. Watercolor
14 x 20"
(35.6 x 50.8 cm)

The Mansard Roof (1923), a superb example of Hopper's early work in watercolor, was first exhibited in the Brooklyn Museum show, then was purchased by the museum for $100. Its beauty lies in its straightforward recording of, as Hopper himself put it, "sunlight on the side of a house."

> ***FYI:*** **Watercolor**—Watercolor is an exacting medium that does not easily lend itself to experimentation. It can, however, yield spectacularly clear and brilliant renderings of color and light. The watercolor painter must place the water-based pigments onto paper in a particular order—starting with the lightest colors and working up to the darkest—in order to achieve a stirring representation. Once the pigment is applied, it cannot be removed.

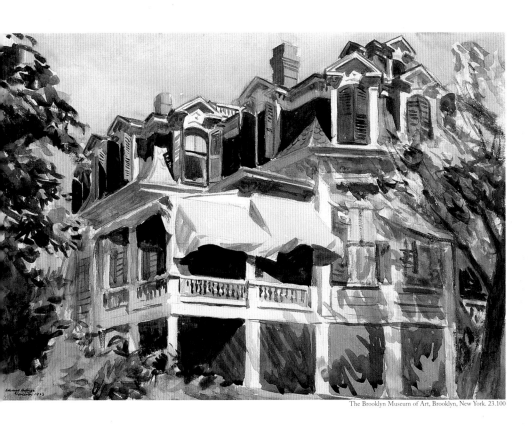

Edward Hopper
Gloucester 1923

The building itself is fanciful, with its mansard roof, gables, chimneys, and porch. The focal point of the work, however, are the two awnings that shade the porch and blaze and billow in the bright, hot sunshine.

Hopper's Watercolors

Hopper's ease with watercolor grew out of his lifelong fondness for architecture—most of his watercolors were of buildings—as well as his strong training as a commercial draftsman. The resulting works are fresh, crisp, and spontaneous.

That fall, Jo Nivison, who had been invited to submit some of her own watercolors for an exhibition at the Brooklyn Museum, recommended Hopper's watercolors to the curators there. In the end, they accepted six of Hopper's works and six of Nivison's. At the exhibition, Hopper's work received top reviews. Hers, unfortunately, were completely ignored.

Within a year, after another summer of painting watercolors in Gloucester, the 41-year-old Hopper exhibited at a commercial gallery for the first time. The November 1924 exhibition with Frank K. M. Rehn in New York featured only watercolors, but was an immediate critical and financial success.

Compared to Hopper's oil paintings and etchings, his watercolors seem breezy and lighthearted. Free of the ponderous emotional content of the oils, they are often simple records of light, atmosphere, or

Sound Byte:

"Just to paint a representation or design is not hard, but to express a thought in painting is. Thought is fluid. What you put on canvas is concrete, and it tends to direct the thought. The more you put on canvas the more you lose control of the thought."

—HOPPER

architectural detail. This may be because, throughout his life, Hopper would paint watercolors when he traveled—and travel itself served as a sort of escape from Hopper's more serious work in the studio. In the end, oil painting would prove to be a more deeply expressive medium. Even so, the summery brilliance of Hopper's outdoor watercolors is a wonder to behold. Over time, they have become some of the best-loved images in American art.

With the **Rehn exhibition,** Hopper had finally established himself as a popular painter. He soon quit work as an illustrator and devoted himself full-time to his painting. After being included in "Paintings by 19 Living Americans" at The Museum of Modern Art in December 1929, Hopper was actively taken up by the press.

Hopper's late Marriage to his Leading Lady

Shortly after the Brooklyn Museum exhibition, Hopper asked Jo Nivison to marry him, and she accepted. The service took place in New

Sound Byte:

"Maybe I am not very human. What I wanted to do was paint sunlight on the side of a house."

—HOPPER, in the mid-1940s

York on July 9, 1924. Hopper was nearly 42 years old; his bride, 41. Hopper's friend, Guy Pène du Bois, had long felt sorry for Hopper, who seemed lonely, alienated, and hungry for attention. In a diary entry of November 30, 1918, du Bois wrote, "Should be married. But can't imagine to what kind of woman." The two were "so opposed to each other in temperament that they were a continuous source of life and dismay to each other," recalled critic Brian O'Daugherty, who knew them in later life.

Small and birdlike, Jo Nivison had met Hopper years earlier at the New York School of Art, where she, too, had studied with Henri. Both an artist and actress, she was intelligent and, like Hopper, strong willed. A true bohemian, Jo Hopper disliked cooking and once listed her usual menu in the Hopper home as either canned beans or canned pea soup, further noting that "just the opening of cans is bad enough."

The Hoppers' late-life, childless marriage seems to have been less one of passion than of sympathy and convenience. Both Hopper and his wife loved literature, poetry, and the arts, particularly theater. Both had traveled in Europe, shared a romantic nature, and were deeply

immersed in painting. But they became known for their quarrels, which sometimes evolved into physical brawls. **Both partners were dissatisfied with their sex life:** Hopper was sexually selfish; Jo, disgusted with his behavior, endured his "attacks" out of a sense of wifely duty. An awareness of this unhappiness is relevant to an understanding of Hopper's art, which even after his marriage featured many strong images of loneliness, claustrophobic isolation, and desire.

A Frugal Married Life

The Hoppers lived a quiet, modest life despite the sustained success Hopper enjoyed beginning with the 1924 exhibition and lasting to the end of his life. After their marriage, Jo Hopper took up residence in Hopper's small studio apartment. The austerity of their lifestyle was remarkable: Both Hopper and Jo dressed inexpensively, preferring to wear their clothes until they were threadbare; they ate simply and had little furniture. Apart from a car and a sparsely furnished one-bedroom country house on Cape Cod, the only thing on which the Hoppers regularly spent money was culture. They attended movies and theater, bought books, and were frequent visitors to galleries and museums.

Hopper's frugality was due, in part, to the times. During the Great Depression, everyone lived simply, and artists faced a difficult life. After the Depression, Hopper's work slowed to as few as two paintings per year, so despite his success he was usually worried about money.

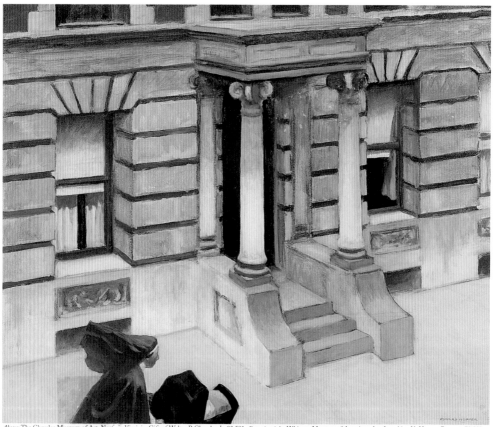

Jo Hopper's Contribution to Hopper's paintings

After marrying Hopper, **Jo forbade him from using other women as models,** perhaps o ⸏ jealousy, and perhaps out of a desire to control and influence her hu ⸏⸏ art. Whenever Hopper depicted a woman after his marriage, tha ⸏ was based entirely upon Jo, even if he made his character youn⸏ ⸏r older, or altered the appearance of her face. The former actress thus became her husband's perpetual "leading lady."

Over the years, Hopper would feature his wife in a number of harsh depictions of female sexuality, even late in life when her body was well past its prime. She appears in his paintings as a stripper, a prostitute, and a big-busted secretary in a tight skirt. She is a haggard older woman smoking naked in a motel room. She is any number of cheap, blowsy women lingering in dingy restaurants and hotel lobbies.

But the women in his paintings are not always recognizable as Jo. *New York Pavements* (1924) is a remarkable work in that, while it portrays a New York street scene, that scene seems vaguely French—and not just because of the Catholic nun pushing the pram. Hopper

ABOVE
Portrait of Mrs. Hopper 1945–50
Charcoal on paper
18 x 15 ½"
(45.7 x 39.4 cm)

OPPOSITE
New York Pavements. 1924
24 x 29"
(61.0 x 73.7 cm)

Sound Byte:

"[In my pictures] the color, design and form have all been subjected, consciously or otherwise, to considerable simplification."

—HOPPER, in 1939

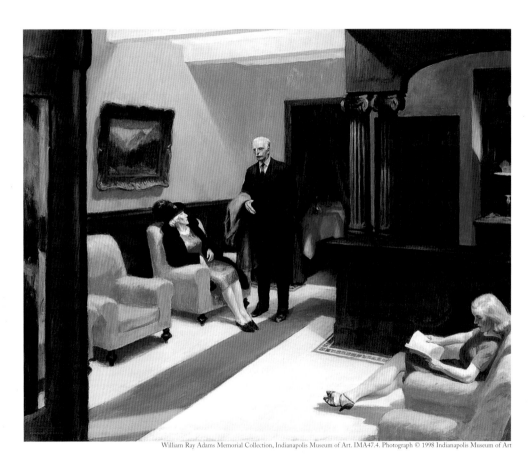

borrowed the compositional device—an off-center view of a subject—from Degas, but he made the composition his own by employing one of his own signature "voyeuristic" viewpoints: The scene is portrayed from above, as if from the window of a neighboring apartment. (Hopper's extraordinary talent in capturing atmosphere and light off-sets the compositionally "impossible" space he sometimes describes. Notice that if the nun were to enter the building, she would find that entrance a pretty tight squeeze.)

Jo Hopper took a strange delight in these make-believe tableaux. Besides standing in as a model, she shopped for props, recorded the progress and design of the paintings in a journal, and maintained scrupulous records of her husband's career.

She was not, however, without bitterness. Throughout her married life she felt that her art had been overlooked in favor of her husband's. Given Hopper's depressive and isolated nature and his wife's chronic dissatisfaction with the progress of her own career, their relationship

Sound Byte:
"He is a quiet, retiring, restrained man who has been working for a number of years in New York and Paris, almost as a hermit, rarely exhibiting and rarely appearing in those places where artists gather, though known by and knowing most of them."

—GUY PÈNE DU BOIS, a friend of Hopper's

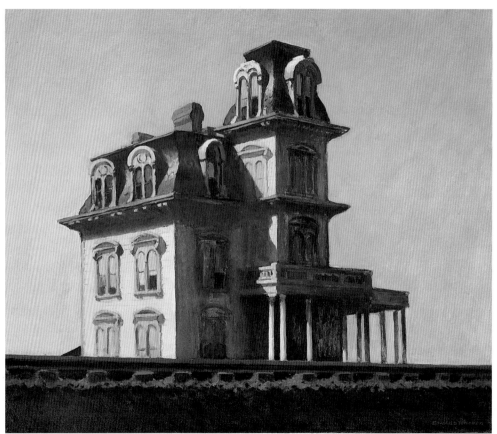

was understandably prone to conflict. Yet it was the only significant relationship of Hopper's adult life, and Jo was immensely important to him as his lover, helper, keeper, and friend. His many portrait sketches of Jo Hopper, which stand apart from the rest of his work, reflect the intensity of his feeling for her: They are among his most tender and observant works.

Hopper hits pay dirt: *House by the Railroad*

With the new confidence generated by his financial success in watercolor, Hopper returned to his first love, oil painting. The spectacular *House by the Railroad* (1925) marked Hopper's new mature style and vision.

The stately Italianate Victorian home depicted in this painting—strongly modeled in a sunlight so particular to Hopper—can be viewed as a study in architectural pathos. The grandiosity of the structure, with its chimneys, mansard roof, gabled tower, and multi-columned portico, is undercut by its stark outline in a treeless landscape and by the blighting proximity of the railroad tracks in the painting's foreground. Hopper himself recalled it as an impression of many such homes he

OPPOSITE
House by the Railroad
1925. 24 x 29"
(61 x 73.7 cm)

OPPOSITE
Eleven A.M.
1926
28 ⅛ x 36 ⅛"
(71.3 x 91.6 cm)

had seen, "with an air of faded glory…before the railway came. It represents a house of the President Grant era."

Many critics have found Hopper's interest in derelict or forgotten buildings to be overly sentimental. When questioned about the nostalgic nature of paintings such as *House by the Railroad*, Hopper replied, "That isn't conscious…but why shouldn't there be nostalgia in art?"

Eleven A.M. (1926) is perhaps Hopper's most erotic painting. Jo Hopper, of course, is the model. Hopper admired the simplicity of the early Dutch and Flemish masters, and the Dutch master whose work he liked the most is probably **Jan Vermeer** (1632–1675), whose paintings depict women seated or standing near windows and whose concern is with the mysterious and transformative quality of light. In *Eleven A.M.*, the notion that the woman is undressed at midday, but for her shoes, suggests a reference to Manet's scandalous *Olympia* (1863), as translated by Hopper into a characteristically seedy American setting, a grimy tenement apartment with a window overlooking an air shaft.

72

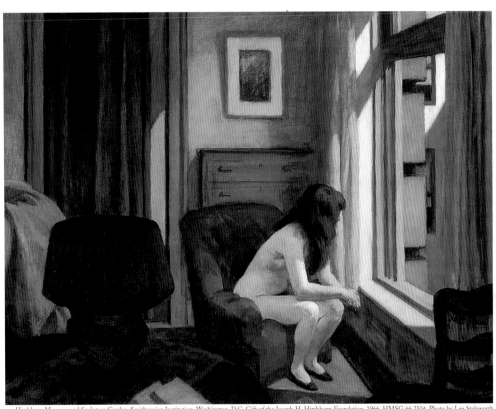

Rather consistently, Hopper's art shows a certain eroticism. His lonely public spaces are rarely populated by single men, but single women abound—and this is no coincidence. In *Automat* (see page 21), the woman alone at night in the automat (a cafeteria using coin-operated machines to dispense food) sits facing the viewer with her eyes in shadow but her lips and bust enticingly illuminated. The automat exists only in the series of hanging light fixtures reflected in its darkened window, but the title is relevant since it refers to the dehumanized nature of the machine age. During his unproductive periods, Hopper himself spent time at a neighborhood automat, where he read the paper and did crossword puzzles to pass the time. His extraordinary awareness of light and space—in this case, bleak overhead incandescent light in a cavernous space, as reflected in darkened plate glass—is part of what made him a consummate observer of 20th-century urban life.

It is almost impossible to look at *Drug Store* (1927) without noticing the prominent wording of "EX-LAX" (a commercial laxative) on the brightly lit windows of the shop. *Drug Store* was originally titled *Ex-Lax* until the art dealer's wife suggested that the title "might have indelicate implications." (In 1927, a pointed reference to any bodily function was considered coarse and crude.) Hopper wanted to show the extent to which vulgar advertising had begun to impose itself upon everyday American visual experience. Note the red, white, and blue of

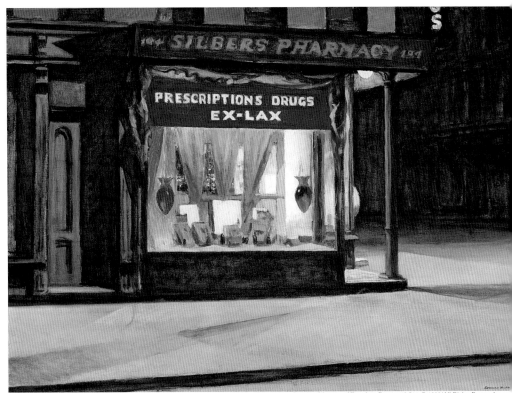

the shop window, a quietly symbolic suggestion that commercialism and the American identity are closely tied). Hopper made a point of including advertising slogans and corporate logos throughout his oeuvre. Notice the Phillies cigar ad, for instance, in *Nighthawks;* the partially obscured chop suey sign in *Chop Suey;* the bright red Mobil Gas sign and emblems in *Gas;* and the Ford sign in *El Palacio.*

The sale of Hopper's painting *Two on the Aisle* (1927) helped pay for his first car, a used 1925 Dodge. With this purchase, the Hoppers began touring the country, starting in 1927, painting roadside scenes from its back seat. Hopper's favorite way of painting on the road was simply to look out of the car window; he disliked painting *en plein air.*

But if he disliked painting outside, he excelled at painting indoors. *Chop Suey* (see page 4) is remarkable for its portayal of two women dining together, for Hopper's world otherwise seems to be populated entirely by women alone or in the company of men. Like many of Hopper's women, the one facing the viewer seems to stare out at the painter with a blank, masklike, come-hither look that transforms the dingy, barely lit interior into one of sexual energy. But in fact, Jo Hopper modeled for all three women (the third woman is just barely visible on the far left of the painting). *Chop Suey* chronicles a kind of cheap restaurant popular in Hopper's day, in which the dining room was located not on the expensive ground-floor real estate, but rather one flight up—which accounts for the looming red "Chop Suey" sign partially visible through

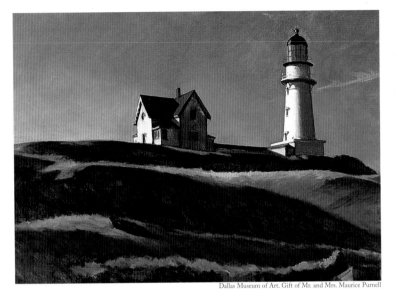

Lighthouse Hill
1927
29 $\frac{1}{16}$ x 40 $\frac{1}{4}$
(73.82 x 102.2 cm)

the window. This particular restaurant interior is based on a place Hopper and his wife frequented on Columbus Circle.

Summers on Cape Cod

Alongside his life in New York, Hopper spent time in South Truro, Massachusetts, on Cape Cod, where he built a summer home in 1933 as a sort of counterpoint to the city's pressures. It was the greatest financial investment of his life. Given his lifelong interest in American

architecture, the house is important in that its design, construction, and site reveal a great deal about Hopper's own personal style.

The house stood on a piece of land 70 feet above sea level, overlooking Cape Cod Bay and distant Provincetown. Open air and a view had always been important to Hopper, who grew up with a similarly sweeping view of the Hudson at his home in Nyack, and who had moved from the apartment on the north side of his New York brownstone to the south side simply to have a view of Washington Square.

Neither Hopper nor his wife enjoyed the idea of creating a bourgeois, suburban-style home with a flower garden and picket fence. Instead they wanted, in Jo's words, "something with the smack of adventure about it."

The result was a stark, shingled cottage with a large, high-ceilinged studio as the main room, with a small bedroom, bathroom, and kitchen as subsidiary rooms. The studio interior was painted white with gray flooring, which increased the sense of light and air in the room. The studio, lit by an enormous thirty-six pane window, and warmed by a brick fireplace, looked out over Cape Cod Bay. The cumulative effect of all this light, air, and water, according to those who visited, was very much like being aboard a ship at sea.

During his summers on Cape Cod, Hopper regularly painted pictures of local roadside homes and farms. *Ryder's House* (1933) depicts a

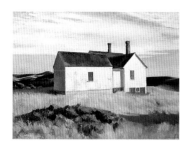

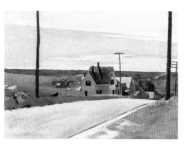

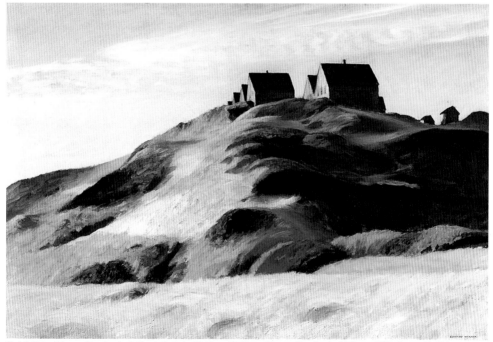

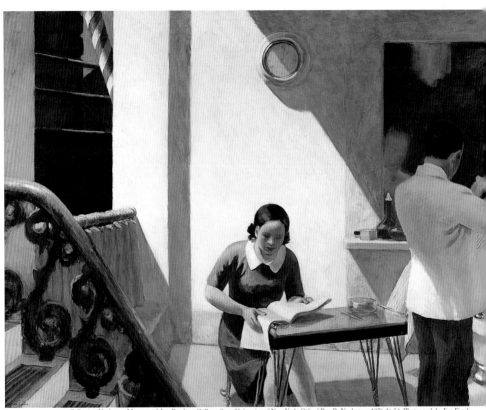

small cottage, the home of the American painter **Albert Pinkham Ryder** (1847–1917), on the southern end of South Truro. Hopper never commented on the image, except to note that, unlike most of his oils, he had painted this image in the open air. The small, solitary white building suggests the ultimately private and hermetic existence of this great American artist.

Depressed Man Chronicles the Great Depression

With the stock market crash of 1929, America entered the Great Depression at roughly the same moment that Hopper was coming into his own as a painter. Hopper's first career retrospective would be held during the depth of the Depression, in 1933, at The Museum of Modern Art in New York. His melancholy work had clearly struck a sympathetic chord in people struggling with the collapse of the American Dream.

OPPOSITE
Barber Shop
1931. 60 x 78"
(152.4 x 198.1 cm)

From the early 1930s onward, Hopper's major paintings break down into five distinct subjects which describe the changing look of America during the Great Depression:

- **automobiles** and mass transportation systems or structures (railroads, bridges, and highways)

- **unattractive industrial architecture** and engineering projects

- **unsettling domestic or office scenes,** usually occurring in an unsightly or crowded urban environment

- **anonymous urban and roadside spaces** for entertainment and relaxation, often featuring anonymous, world-weary, apparently "single" women: shop girls, secretaries, and (possibly) prostitutes

- **abandoned or derelict farmland** and countryside, most often seen from a roadside perspective

Many of Hopper's psychologically charged tableaux describe acts of voyeurism and deal with different forms of loneliness and isolation. Jo Hopper's early acting career and Hopper's own lifelong passion for theater led him to create these haunting, open-ended images, which may reflect as well on their own troubled marriage.

Room in New York (see page 29) is a good example. A couple sit quietly in their brightly lit living room at night, the man absorbed in his newspaper, the woman lost in thought. They coexist but do not interact. The deadly stillness of the scene is accentuated by the woman's touch upon a piano key: In a moment, the silence of the room will be broken. Hopper's view of the scene comes from outside the window, lending the image an eerie, slightly menacing quality.

First Retrospective: The Museum of Modern Art in 1933

Within ten years of his first successful gallery exhibition in New York, Hopper was given a career retrospective at The Museum of Modern Art in New York. Despite the pleasure that should have come from the attention lavished upon his work in the retrospective, Hopper took a characteristically dour outlook on the event. When congratulated by a friend on his high honor, Hopper referred to it darkly as "the kiss of death." The retrospective, however, was a triumph.

What did he do for an Encore?

As the success of his first retrospective calmed down, Hopper settled once again into his life as a successful chronicler of the American Scene. The "kiss of death" comment notwithstanding, Hopper had nothing to fear: His greatest paintings were still ahead of him.

Thus far in his career, Hopper's paintings fall into **three categories:** cityscapes, intimate scenes, and landscapes.

1. URBAN SCENES: *HATES SKYSCRAPERS AND NEW ARCHITECTURE; PREFERS BROWNSTONES*

Hopper is the foremost chronicler of late 19th- and early 20th-century urban and domestic American architecture. Residential buildings, particularly older private homes, always interested him, as we've seen in

House by the Railroad. Without drama or sentiment, Hopper also had the ability to create images that perfectly described the look and feel of everyday urban America. One of his best-known images of urban America is *Early Sunday Morning* (see pages 86–87), a canvas showing the spirit of small, service-oriented businesses during the tough times of the Depression: The barber pole on the sidewalk may be tilted, but it's "still there." His other works of small-scale urban buildings include *Sunlight on Brownstones* (1956), a fascinating study in the use of light, and *Room in Brooklyn* (1933), which presents a neat but spartan apartment interior in which a series of windows open onto a flat, featureless series of anonymous brownstones (see page 26). Flowers sitting in sunlight provide a simple focal point for the painting, and the blinds set at different levels provide additional visual interest. To the left of center, a woman sits with her back to the viewer, her own anonymity echoing that of the view. Despite the dreary Brooklyn roofscape outside, the picture is not without charm: It depicts a clean, quiet, contemplative domestic environment. Hopper, as if to explain away the cheer of the room, once noted that it was his "only painting with flowers."

Other, more typical paintings of the urban landscape, however, tend to portray less-welcoming spaces and structures. In the Ashcan tradition, **Hopper perceptively noted the dehumanizing effects of 20th-century architecture,** including skyscrapers, bridges, highways, and commercial signage. He repeatedly painted scenes of failed urban

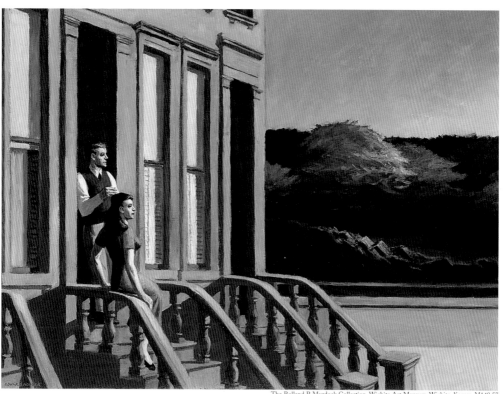

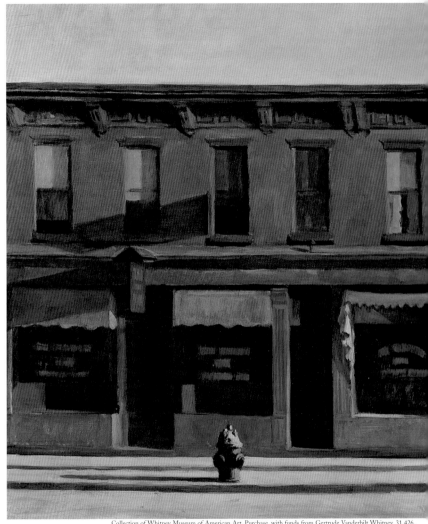

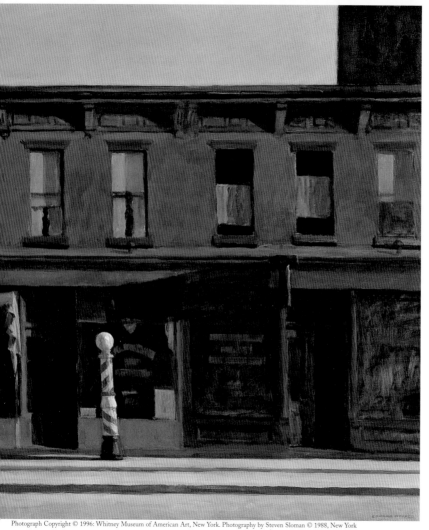

planning: *The City* (1927) presents an ugly hodgepodge of architectural development; *Manhattan Bridge Loop* (1928) describes a roadside "no man's land" created by the construction of the Manhattan Bridge; *Approaching a City* (1946) shows the intrusion of a railroad viaduct coursing through a residential environment. At a time when many American artists—Georgia O'Keeffe, for one—celebrated the skyscraper, Hopper was resolutely opposed to the changes wrought by modernity and particularly disliked the dehumanizing scale of the skyscraper.

2. DOMESTIC AND OTHER INTIMATE SCENES: *OR, PEEPING HOPPER*

Along with his cityscapes and landscapes, Hopper began delving into a more deeply personal world of figured interiors (i.e., interiors with people in them). The drama of people who are glimpsed while living their lives would fascinate Hopper for the rest of his life and animate his greatest paintings.

3. ROADSIDE LANDSCAPES: *OR, HOPPER HITS THE ROAD*

Hopper and his wife particularly loved New England, and throughout his life many of the brightest and most exhilarating images he composed were of nautical scenes or marine structures such as lighthouses and homes overlooking the sea. One such painting (on page 24) is *Ground Swell* (1939), about which Jo Hopper noted, "Sail boat, boys nude to the waist, bodies all tanned, lots of sea and sky…a beauty."

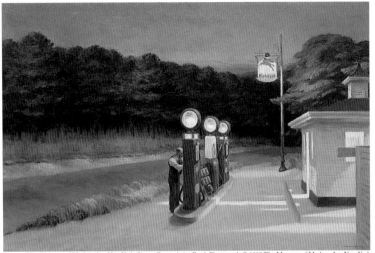

Gas. 1940
26 ¼ x 40 ¼"
(66.7 x 102.2 cm)

More typical of the roadside landscapes, however, is the beautiful painting *Gas* (1940), based on an actual Mobil station in South Truro, Massachusetts. For an entire generation of Americans, bright-red gas pumps were a familiar roadside vision, and Hopper's portrayal of the gas station at dusk—with the woods behind growing dark at twilight—prompted Lloyd Goodrich, Director of the Whitney Museum and one of Hopper's greatest supporters, to observe that "this familiar image expresses all the loneliness of the traveler at nightfall." Today, such roadside stations have all but disappeared, as has the more easygoing lifestyle that supported them.

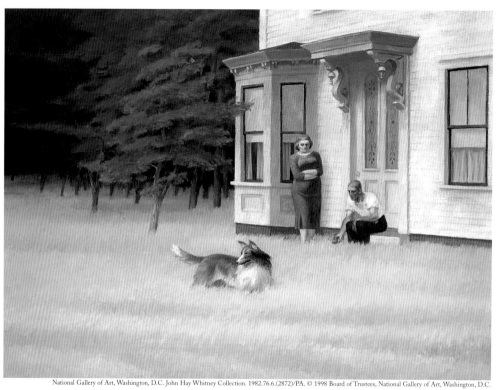

Images of travel and attempted escape comprise a large part of Hopper's oeuvre: Both the sea and the open road held the promise of romantic escape. But his expression of them tends to be static and at times even claustrophobic. You'll notice that:

- his relationship with the countryside is framed (and limited) by the car or vehicle. In these paintings, we seem merely to be passing through the landscape, rather than interacting with it in any personal way. By means of color and composition, as well as through the depicted scene, the paintings describe a sensation of futility and isolation common to many travelers who never quite "experience" a place because they never leave the car.

- Hopper's pictures of houses and landscapes from 1930 onward usually feature roads and/or common roadside buildings, particularly anonymous-looking gas stations and motels. Hopper was one of the first American painters to realize that the automobile had reduced the average person's experience of the American landscape to that of a pit stop along a roadway.

An Isolated Artist, with Abstract Expressionist fans

During Hopper's lifetime, a fundamental change swept the New York art world. When Hopper came to New York in the early years of the century, realism was the dominant style of painting, and it remained so during the 1930s. By the end of the 1930s, however, Surrealist and

OPPOSITE
Cape Cod Evening
1939
30 ¼ x 40 ¼"
(76.8 x 102.2 cm)
framed: 42 x 52"
(107 x 132 cm)

Abstract Expressionist art had come into vogue, and most forms of realism were considered "dead." Not with Hopper, though. The critical dialogue surrounding contemporary art became almost exclusively focused on issues related to avant-garde art—specifically, to abstraction. Hopper remained a realist.

In *New York Movie* (see page 10), Hopper returned to the theme of the isolated (female) figure in a public space. Whenever he was having a difficult time with his painting, Hopper haunted the movies. This subtly erotic image of a pensive—or dozing—usherette was doubtless inspired by his restless wanderings through movie theaters. In that sense, the image recalls *Automat* (page 21), since automats were another favorite place for Hopper to while away his hours. *New York Movie* was a difficult painting for Hopper, who struggled for months to capture a convincing evocation of the darkness, saturated hues, and dim artificial lighting of the theater. Some critics feel that Hopper subtly addresses the issue of "High" and "Low" art in this painting. Movies were, of course, the reigning popular entertainment of Hopper's time, the ultimate triumph of mass-produced kitsch. The ersatz décor of the movie theater, the bleak artificiality of the light, and the bored insouciance of the usherette all gently suggest the lack of fulfillment or consolation afforded by Hollywood films. Regardless of one's interpretation, the painting remains a splendidly moody rendering of an anonymous public interior space, one made evocative by the presence of a vulnerable female.

Starting in 1940, Hopper, though successful, was outside the artistic mainstream. By nature a loner, he had little interest in critical issues or in being part of the art scene, so he was relatively unaffected by the changes sweeping that world. He had a substantial following among art collectors, museum curators, and the general public, but also among many important painters of the avant-garde—including **Mark Rothko** (1903–1970), **Franz Kline** (1910–1962), and **Willem de Kooning** (1904–1997)—who had a grudging respect for Hopper's masterly use of color, light, and space.

A different kind of intimate interior can be seen in *Office at Night* (on the next page), an erotically charged image of a businessman and his secretary working late at the office. Hopper and his wife, who modeled for the secretary, tried to supply stories for this image, perhaps to dispel its unsettling effect upon them, for the theme is, of course, one of illicit romance and implied infidelity. According to notations made by Jo Hopper, she humorously nicknamed *Office at Night* "Confidentially Yours, Room 1005." The secretary, with her large, sexually suggestive breasts and hips, was dismissively nicknamed "Shirley." When questioned about *Office at Night* Hopper said, "it will not tell any obvious anecdote, for none is intended." *A design note:* Hopper frequently resorted to the creation of physically impossible spatial relationships to achieve a desired emotional effect. In *Office at Night*, the room is skewed and surreal. The severe changes in scale

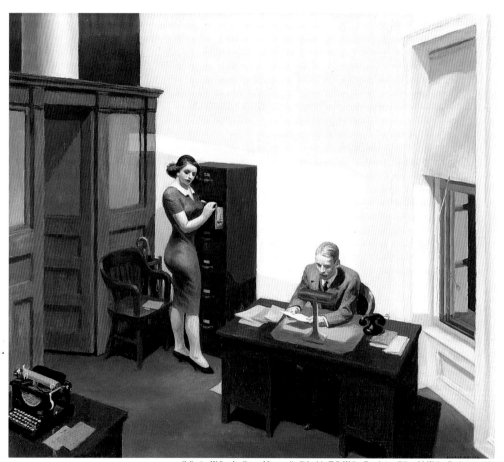

Sound Byte:

Office at Night *(1940)* "*was probably first suggested by many rides on the 'L' train in New York City after dark and glimpses of office interiors that were so fleeting as to leave fresh and vivid impressions on my mind. My aim was to try to give the sense of an isolated and lonely office interior rather high in the air, with the office furniture which has a very definite meaning for me.*"

—HOPPER, 1948

between table, desk, and filing cabinet would not be possible in "real" space, but the image is nonetheless convincing.

The Big Show-Stopper: *Nighthawks*

Of all his paintings, Hopper's most celebrated and mysterious painting is certainly *Nighthawks* (1942), an image of a glass-windowed diner late at night. Its title suggests a lurking predatory presence, but just who that predator may be and what is going on is impossible to know. Hopper, who hesitated to tell the "story" of *Nighthawks*, remarked to an interviewer that the scene "was suggested by a restaurant on Greenwich Avenue [in Greenwich Village] where two streets meet. I simplified the scene and made the restaurant bigger. I was painting the loneliness of a large city."

OPPOSITE
Office at Night
1940
22 ³/₁₆ x 25 ⅛"
(56.4 x 63.8 cm)

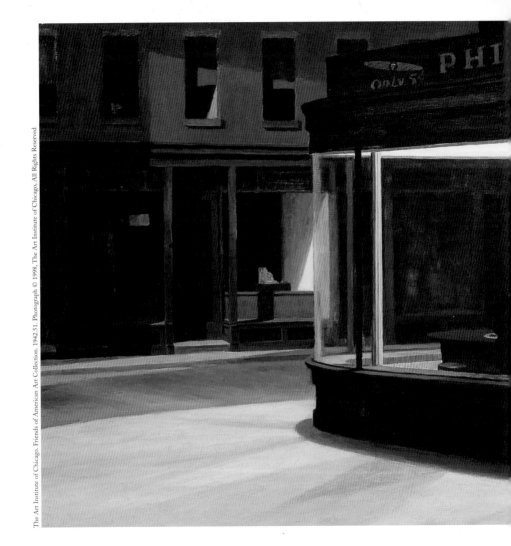

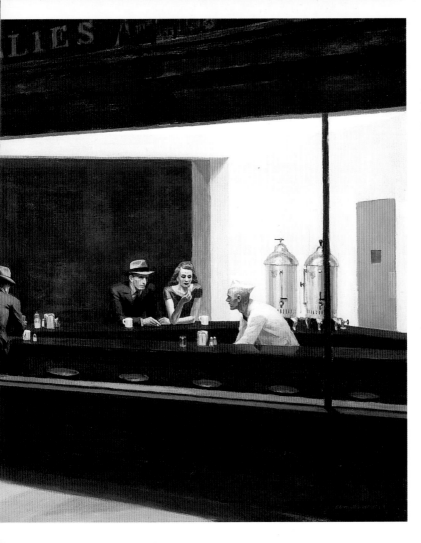

Nighthawks
1942. 33 1/8 x 60"
(84.2 x 152.4 cm)

What's "going on" in *Nighthawks?*

While there is no one plot to explain *Nighthawks*, an observer can notice the following:

- **more voyeurism:** Hopper is once again observing people at night through a window. The seeming inactivity of the people inside the coffee shop is matched by the equally static and cerebral observer of the scene. The powerful mood of the painting is created, in part, by an oppressive feeling of stillness and lack of purpose. The slick couple seems as out of place in this neighborhood diner as many Hopper people feel, psychologically, in their environments.

- **expressive quality of artificial light:** The melancholy atmosphere created by bright overhead lighting, viewed from the darkness outside, is one of the painting's strongest features. Fluorescent lighting, which had come into use only in the early 1940s, floods the diner with light. As in other Hopper paintings, the influence of movies can be felt here: When looking at the painting, it's as if you're seated in a dark movie house, gazing up at the brightly lit screen.

- **"bird" imagery:** The man and woman who sit facing outward both have beaked, hawklike noses. A "nighthawk" is a smallish nocturnal predatory bird. It may be Hopper's variant on the term "night owl," meaning a person who stays up late. The couple seem like outsiders who have swept into this neighborhood where they do not belong.

The point of this painting is ambiguity: For example, the man behind the counter can be seen as old or young, handsome or ugly, etc.

- **"cage" imagery:** The diner represents a sort of glass "cage" for the humans inside. People suffering from depression often feel that they are "trapped behind glass" or "looking at the world through a window." It is worth noting that many of Hopper's people seem caged by or trapped within their environments. A similar "caged" image can be seen in Hopper's South Truro painting *Cape Cod Morning* (on the next page), which depicts a woman gazing out of a bay window.

Nighthawks, photography, and *film noir*

Nighthawks seems to resemble a scene in a movie. In many ways, Hopper's work is more closely related to 20th-century American photography and cinematography than to the avant-garde painting being done by his artistic contemporaries from 1940 onward. Many film critics see Hopper as an important inspiration for the film style of the 1940s and 1950s which has come to be known as *film noir*.

> **FYI:** One of the classics of the *film noir* genre is the Humphrey Bogart movie *The Killers* (1946), based on a 1927 story by Ernest Hemingway. The story is set in a diner late at night—similar to the one in *Nighthawks*. Another good example of a *film noir* is *The Postman Always Rings Twice*, starring Lana Turner.

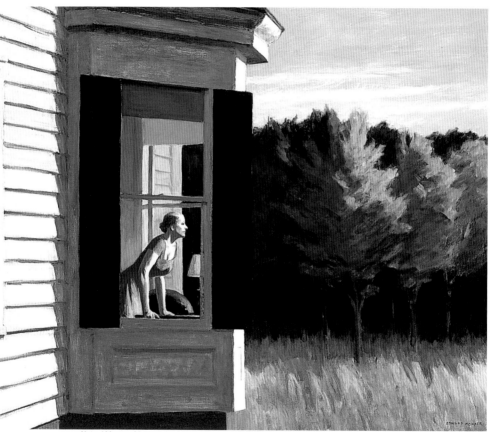

With Age, Hopper becomes Intensely Private

Perhaps because of the intense public curiosity that his popular and troubling paintings aroused, Hopper became an even more private man as he grew older. He did not discuss his personal life and asked his relatives not to talk to reporters about him. Even in conversation with art professionals, he was careful not to delve too deeply into his philosophies, interests, or motivations.

The Late Work: Surrealist or just Weird?

As Hopper looked inside himself to create his imagery, not only did his production slow down, but **he began to move away from "pleasant" or "finished" paintings.** Instead of becoming a more facile painter, he grew more studied and stiff as he aged. In the later paintings, an apparently intentional awkwardness and heavy-handedness abound, and the places Hopper paints look increasingly surreal. Doors open onto nowhere. The women in his painting, ostensibly symbols of desire, become in many instances haglike and bedraggled, with vacant gazes, corpselike faces, and dark, sunken eye sockets. While this may be due, in part, to Jo Hopper's physical decline—she was still his only model—most critics agree that this interest in portraying physical decrepitude was an aesthetic decision on Hopper's part. His late work carries a strong, at times overwhelming, awareness of mortality.

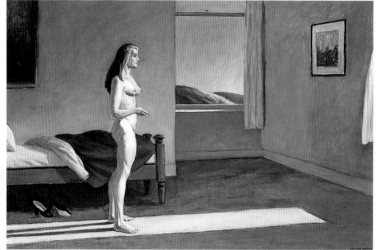

RIGHT
*A Woman
in the Sun*
1961. 40 x 60"
(101.6 x 152.4 cm)

OPPOSITE
Rooms by the Sea
1951. 29 x 40 ⅛"
(73.7 x 101.9 cm)

One possible reason for the increasing roughness of the figures in Hopper's late paintings is that **he became preoccupied with the quality and power of light** rather than with people. One of Hopper's most notable images from this later period is *Rooms by the Sea* (1951), which presents a room opening directly onto the physical embodiment of the existential void: the sea and sky. But the emotional heart of this jarring image lies elsewhere—in the play of sunlight and shadow on the blank walls facing the viewer.

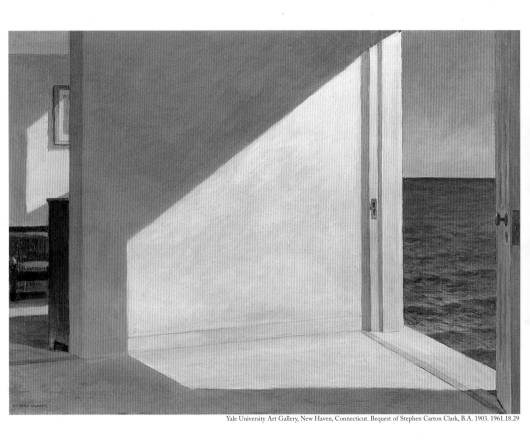

Fan of movies and theater

Hopper shared a lifelong passion for the theater with his wife, a former actress. Critics have frequently noted that the artificiality, heightened drama, and strong lighting of Hopper's tableaux make them resemble depictions of theatrical sets. But theaters themselves also fascinated Hopper, perhaps because they described humankind's willing participation in illusion and make-believe as an antidote to everyday loneliness and despair. One of his finest "theater" pictures is *Two on the Aisle* (1927). Others include *The Sheridan Theatre* (1937), *New York Movie* (1939), *First Row Orchestra* (1951), and his last painting, *Two Comedians* (1965), on page 110.

Forever Bit by the Travel Bug

Western Motel (1957) was painted during Hopper's last venture into the western United States, during a trip to the Huntington Hartford Foundation at Pacific Palisades, near Los Angeles. But the mountainous landscape seems more like Colorado than Los Angeles (see pages 108–109). Hopper rarely worked from actual scenes, preferring instead to work from a number of remembered sources and to use his imagination

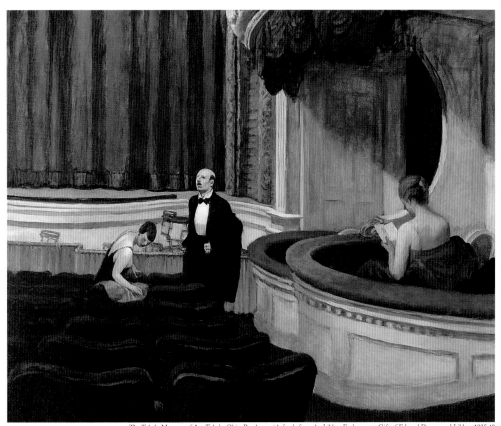

OPPOSITE
Second Story Sunlight. 1960
40 x 50"
(101.6 x 127 cm)

in the composition of his imagery. This is a classic Hopper image, featuring a bed, a solitary woman facing directly out at the viewer (the viewer viewed), a caressing, strong sideways sunlight, and the great symbol of modern progress—the automobile—at center stage.

The Sun Worshiper

Unlike the more convincingly realistic works of his early career, *People in the Sun* (1960) is stark and uncompromising in its vision (shown on page 19). Hopper portrays a group of people sitting together facing not each other, but the setting sun, as if they were getting ready to watch a movie. Light in these late works is both spiritual and sensual: Perhaps these people have turned to the sun for rejuvenation or for physical and emotional consolation. Whatever the case, Hopper seems to be expressing in these later works an abiding awareness of his own mortality. For *A Woman in the Sun* (1961), Jo Hopper recorded in the Hopper ledger books, "E.H. [Hopper] called her 'a wise tramp' begun cold, very

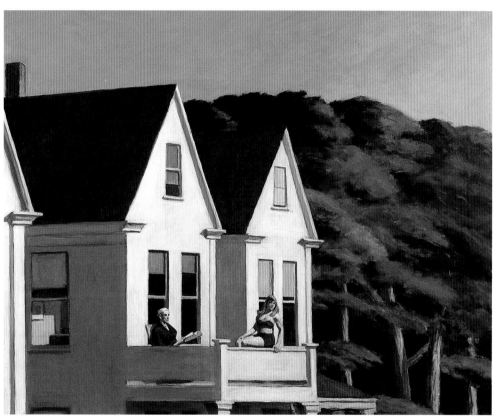

Collection of Whitney Museum of American Art, New York. Purchase, with funds from the Friends of the Whitney Museum of American Art

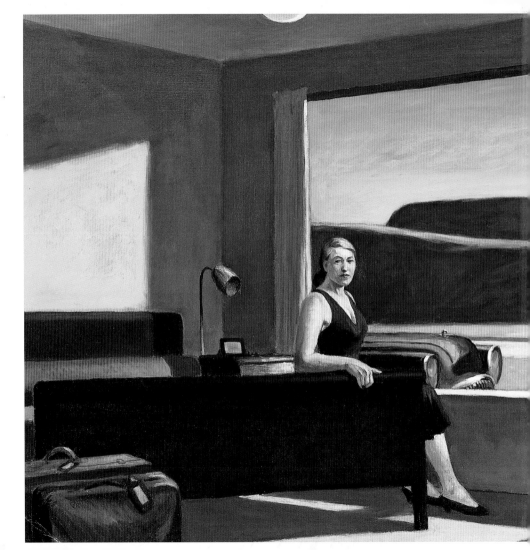

The Western Motel
1957. 30 ¼ x 50 ⅛"
(76.8 x 127.3 cm)

Yale University Art Gallery, New Haven
Connecticut. Bequest of Stephen Carlton
Clark, B.A. 1903. 1961.18.32

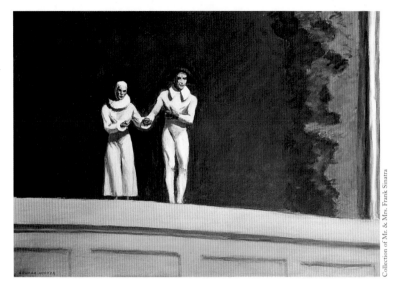

Two Comedians
1965. 29 x 40"
(73.7 x 101.6 cm)

early Oct. 1. Tragic figure of small woman, blond straight brown hair, grabs cigarette before shimmy skirt—brightest note at R seen off stage, on curtain of window off stage right easts [sic]. Cigarette and sad face of woman unlit."

A Long List of Honors and Awards

From the time of his 1933 Museum of Modern Art retrospective, Hopper enjoyed a remarkable run of success. Few artists have been so highly celebrated in their lifetimes. In 1952, along with three other

artists, Hopper represented the United States at the Venice Biennale, a major exhibition of contemporary painting held every two years in Venice, Italy. In 1967, he was the central figure in the U.S. Pavilion of the São Paulo Biennale, a similar South American festival of contemporary art. Hopper was elected to the National Institute of Arts and Letters in 1945 and to the American Academy of Arts and Letters in 1955.

A Peaceful Death

Aware of his impending death, Hopper composed a final painting, *Two Comedians* (1965), which evokes his own mortality. In this painting, which Jo called "poignant," he and Jo stand at the edge of a theater stage, dressed as two clowns in traditional *commedia dell'arte* clown costumes. They are taking their final bows, facing the end together.

Edward Hopper died in his Washington Square studio on May 15, 1967 at the age of 84. Jo Hopper died a little less than a year later.

Why People love Hopper

Despite his belief that most artists are forgotten ten minutes after they're dead, Hopper has not been forgotten, nor is he likely to be. Thanks mainly to the tenacity of his vision and to his diligence, perseverance, and great gifts as a painter, Hopper continues to fascinate people of all nationalities.

Few of his admirers know (or care) that the art he pursued throughout his life developed out of his reaction to the French Realism and late Impressionism he had discovered in Paris—and which he had combined with the American realism he had learned about with Robert Henri in New York and had admired in Thomas Eakins.

People visit museums to see Hopper's work because they sense that Hopper, more than any other 20th-century artist, reveals the look and feel of 20th-century America—from the early century, through the Depression, into the postwar years—and about our sense of loneliness, alienation, and crises of identity. His paintings, prints, and watercolors are highly prized by top collectors, not just for their craftsmanship, but for their extraordinary clarity and emotional directness. They speak to everyone.

In the end, Hopper's indifference to the change and innovation of the modern age was hardly reactionary, since, with time, that same ambivalence has become widely recognized as a key aspect of modernist thought. In his honest artistic response to all he saw and felt in the 20th century, Hopper proved himself more modern than he knew.